41 Santa Patterns for Carvers

Al Streetman

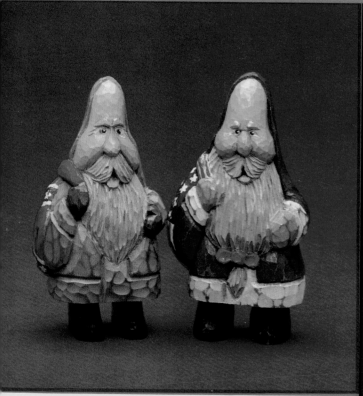

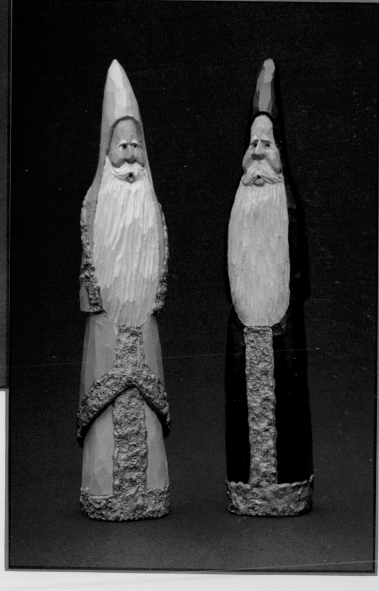

Schiffer Publishing Ltd

77 Lower Valley Road, Atglen, PA 19310

Dedication

To my wife, Priscilla, who has endured countless piles of wood chips, and listened to endless excuses why I just "had to have" one more carving tool. She also provides me with the inspiration to keep going, even on days when I feel too tired to pick up a knife.

Also, to my Mom and Dad. The tree grows as the twig is bent...thanks for having the love and taking the time to see that I was bent in the right direction.

Acknowledgements

I want to thank the following people. Without their help, this book would not exist.

Jack Lisiecki: Good friend, and photographer extraordinaire.

Marilynn Jones: Computer wizard, word processing expert.

Ted Hemmons: Chief worrier.

Delta Technical Coatings, Inc.: Paint samples.

Woodcarver's Supply, Inc., Englewood, Florida: Carving tools and supplies

Copyright © 1994 by Al Streetman

Printed in The United States of America
ISBN: 0-88740-632-7

We are interested in hearing from authors with book ideas on related topics.

Published by Schiffer Publishing Ltd.
77 Lower Valley Road
Atglen, PA 19310
Please write for a free catalog.
This book may be purchased from the publisher.
Please include $2.95 postage.
Try your bookstore first.

Contents

FOREWORD

One of the reasons I attempted my first book "Santa Carving", was to give patterns to those who wanted to carve, but needed something to go by. The monetary rewards have been nice, but the many friends I have made through my books have made me much richer.

One of these friends is Al Streetman. Al contacted me a while back with his idea for a book. I liked the idea and encouraged him to contact my publisher.

This book is the result, and I know you will enjoy the various patterns and poses that allow and encourage you to do some different Santas from materials that won't cost an arm and a leg.

Good carving,

Ron Ransom
Marietta, Georgia
October, 1993

INTRODUCTION

I wrote this book to provide beginning wood carvers with a project which they could accomplish with a minimum of tools and frustration, and also to provide intermediate and advanced wood carvers with an assortment of Santas in different poses. Santa carvings seem to be a popular item with collectors, and also with people who want them for a touch of warmth in their homes. I have not devoted any chapters to the selection, sharpening, or use of woodcarving tools. There are already an abundance of these books on the market. Except for the actual carving project, I have not included specific carving instructions. I have found that each carver has his or her own style, and each has their preference for which tool to use in a particular area, or to achieve a particular effect. The project we are going to carve is based on a pattern I developed in 1991. It is relatively easy to carve and paint, and continues to be a good seller for me.

The patterns in this book include approximate dimensions of the side and front views. If you desire a larger or smaller version, simply enlarge or shrink the pattern on a photocopying machine.

I use Basswood whenever possible, but any soft wood such as Jelutong, clear Spruce, or Sugar/White Pine will work equally well. As a matter of fact, the Santa we are going to carve in the project is made from a piece of plain old 2 x 4 lumber, and 3/4" pine shelving. No matter where you live, you can obtain 2 x 4s and shelving. If your lumber supply store carries western pine or spruce 2 x 4s, you have just found a cheap source of fairly good carving wood!

If possible, use a bandsaw with a 1/8" blade to cut out the side profile. On the patterns with extended arms, you may wish to cut out the front profile instead. Experienced carvers may wish to saw out both the front and side profiles where feasible. The bandsaw will allow you to release the rough version of Santa from the block of wood faster than trying to use a coping saw or other means to cut out the pattern. If you don't have a bandsaw, now is the time to become real good friends with someone who does have one!

before you begin

general notes

1. Trace the pattern, or make a copy of it on a photocopying machine. Glue the pattern you copied or traced onto some heavy paper such as poster paper or a manilla file folder. When the glue is dry, cut out the pattern. This method will prevent you from ruining the master patterns in your book.

2. Lay your pattern on the wood, trace the outline of it, and saw it out. Remember my note above about the patterns with extended arms.

3. You should now have a rough blank ready to be carved.

4. Use your own techniques and style to bring the carving to the finished stage.

tips

1. I often use various sizes of plastic-head quilting pins to make eyes. Mark where you want the eyes to be on the finished carving. Using a drill and bit that is slightly larger than the pin head you are going to use, make a hole for each eye.

Using wire cutters, snip off the pin head, leaving about 1/4" of the pin attached to the head.

Insert the pin head into the eye socket, with the pin end going in first. Use a nail set to seat the head into the hole until only a small orb protrudes. This gives a fairly realistic eye without causing too much effort on your part. For extra detail, remove a triangular shaped piece of wood from the sides of the pin head. This will make a very realistic eye when it is painted.

2. For realistic fur, I use a product made by Delta Technical Coatings, Inc. called "Decorative Snow". This is a white, grainy acrylic mixture that you apply with a small flat brush. After it is dry and painted, it gives a very good fur look.

3. When buying wood, whether it be Basswood, Spruce, or some other type, try to pick the **lightest** pieces. They tend to have less fat and sap in them, so they are **easier** to carve.

4. An easy way to make stars is to take a stylus or toothpick and put a dot of white paint where you want the star to be. Starting inside the dot, while the paint is still wet, drag the tip of the stylus or toothpick toward the edge and out to make a line. Do this for all five points of the star. The bigger you make the dot of paint to begin with, and the further you drag each line outside of the dot, the bigger the star will be.

general painting suggestions for all santas in this book

I have included suggested colors for all patterns. If you have a preference for a different color scheme, by all means use it. After all, it's your Santa. You may want to try different robe and fur colors on some of your carvings. As an example, Blue robes with white or gold fur, or purple robes with dark grey fur make very nice color combinations.

Listed below are the colors produced by Delta Technical Coatings, Inc. which I have found to be suitable for Santa painting. I have used these colors, and the results were excellent. I hope this will help minimize your confusion when trying to sort through the maze of paint brands and colors at your hobby or craft store.

White (Beards, eyes)
Antique White (Fur)
Black (Boots, belts, mittens, dot in eyes)
Antique Gold (Wooden shoes, star, fur on Confederate Santa's coat)
Avocado (Mittens)
Christmas Green (Trees)
Fleshtone (Face, hands)
Sweetheart Blush (For blending on face and nose areas)
Blue Heaven (Light Blue for dot in eyes)
Liberty Blue (Northern and Uncle Sam Santa coats)

Prussian Blue (Blue on flags)
Kim Gold (Belt buckles)
Lichen Grey (Confederate Santa coat)
Crimson, Cardinal Red, Berry Red (Coats, flags and stripes, bricks)
Tompte Red (Hearts)
Autumn Brown (Sacks, Western Santa boots)
Quaker Grey (Cement)
Warm Brown antiquing gel (For "aging")
Clear Satin varnish (For finishing and sealing)

FACE: Flesh, with a small amount of blush blended into the cheeks and tip of nose for a weathered, wind-burned look.

EYES: White base. Then paint a dot of light blue in the center, corner or top of eye. Next, paint a smaller dot of black in the blue dot. Finally, use a toothpick and put a white highlight on the edge of the black dot. In the section where I paint the carving project, I'll go into more detail on placing the highlight, depending on where the eye is looking.

BEARD AND EYEBROWS: White

COAT/ROBE AND TOP PART OF HAT: Red

FUR AROUND HAT, ON SLEEVES, AND ON COAT/ROBE: Antique white

BOOTS: Black

BAGS: Autumn brown

Some patterns in the book have specific colors in some areas. Where these colors are required, I have included them with the pattern.

Some patterns also have specific requirements, such as a base to support the weathervane, or a way to hang the Icicle Santas. I have included the required information or directions with the pattern.

"antiquing" the project

Once the paint is dry, you may want to "age" your Santa with an antiquing product. I have had excellent results using antiquing gels made by Delta Technical Coatings. These are available at hobby and craft stores. They come in various colors, so you can create different effects.

Brush a coat of antiquing gel on the carving, then wipe it off using a damp rag or sponge. It is your option how much you wipe off. After the antiquing is dry, I like to finish my carvings with a coat of brush-on acrylic varnish. Delta Technical Coatings also makes an excellent varnish. I prefer the one that leaves a Satin finish. This particular finish is not too flat nor too glossy, but leaves a "soft" look to the completed carving. **(I usually put a coat of varnish on the face and beard area BEFORE I antique the carving).** This will prevent these areas from absorbing too much antiquing color.

I hope that in some way I have been able to help each of you with some aspect of carving and painting. When we share tips and information, we all become better. If you have any comments or questions about something in this book, or if you have an idea you'd like to see me put in a future book, please feel free to write or call me at the following address and telephone number. I welcome any comments or suggestions you have.

Al Streetman
1609 N. Fordson Drive
Oklahoma City, Ok. 73127
(405)495-0816

carving the project

We are ready to begin turning a few dollar's worth of wood into a valuable masterpiece that you will be proud to display. We'll do this project step-by-step, in the sequence I use when I make one of these Santas. After completing the project, if you discover a method that is easier for you, use that method. None of my techniques are cast in concrete, and I am always glad to learn new tricks of the trade.

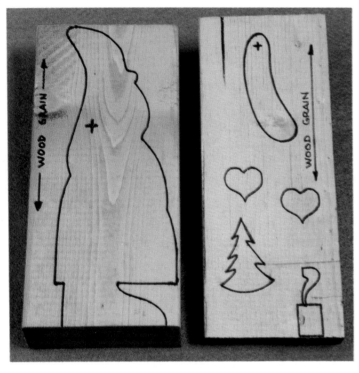

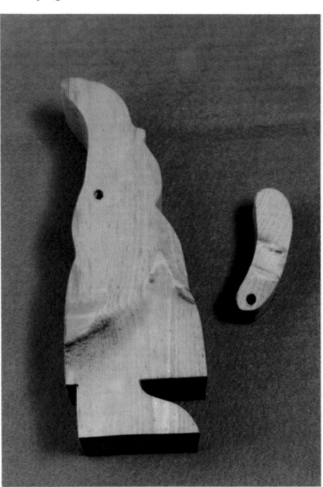

After gluing your patterns to stiff paper and cutting them out, trace the outline of the **body** onto a section of 2 x 4 lumber, and the outlines of the **arm, hearts, tree, and pipe** onto a section of 3/4" shelving. Notice that I have left a small block of wood at the end of the pipe stem. This will give you a handle to hold while trimming the pipe with your knife. We'll cut it off later, when Santa is ready for a smoke.

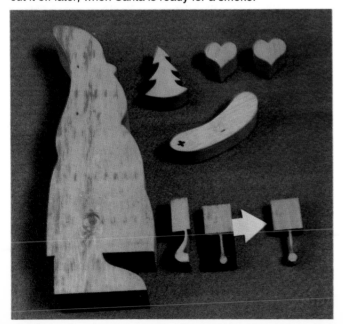

Next, drill 3/16" holes in the body and arm. The "+" on the pattern shows where to drill the holes. If you have a drill press, you can drill the body hole all the way through from one side. If not, lay the pattern on one side of the body and mark the "+" with a small nail or other sharp tool. Repeat this procedure for the other side of the body. Drill from each side, and try to keep the holes lined up. It is not absolutely critical if you are off a small amount, but if you get the arm holes too uneven, you will get a strange looking Santa. Also, drill the "+" on the arm all the way through.

Now, saw the pieces out with a bandsaw, or other means. Notice that the pipe is sawn twice. First, saw out the side profile as the pattern shows. Next, sketch in the top view and saw it out. This will leave your pipe in a nearly finished state, and we can easily finish carving it in a later step.

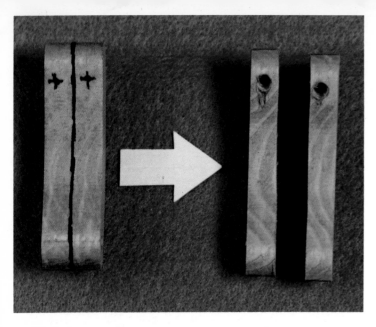

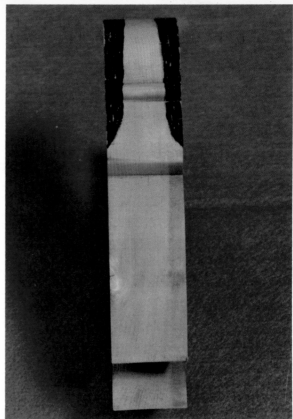

Turn the arm on its edge and draw a pencil line along the length, down the center. Mark a spot as shown on each side of the arm, in the hand area. Drill 3/16" holes through the hands. Later, these holes will be used to used to allow Santa to "hold" the hearts and tree. After drilling the holes, saw the arm in half, following the line you drew along the center. Presto!! Two arms for the price of one.

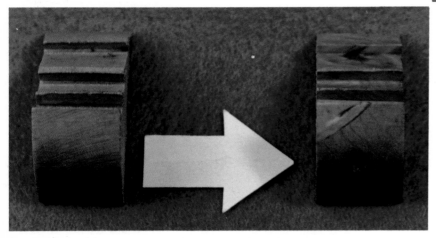

Lay the body on its back. Now we need to mark some lines to guide us in sawing a tapered angle from the top of the shoulders to the top of the hood. Starting about 1/4" above the hole you previously drilled for attaching the arms, sketch some shoulders, and as you move up toward the top of the head, sketch in the taper. There is no hard and fast rule here. You can make a wide taper if you want Santa to have a fat, jolly face, or you can make a narrow taper for a lean and hungry looking Santa. As you carve the different patterns, experiment with various combinations so your Santas will all have their own personality and "look". In the photo, I have also darkened the sections of wood which will be removed when I saw out the taper. **On all future steps in this project, I will use this darkened wood method whenever possible, so you will be able to clearly see where the wood is to be removed.**

Turn the tree upside down and drill a 3/16" hole in the base so a dowel "trunk" can be fitted to it later. A hole approximately 1/4" deep will be more than adequate to hold the trunk firmly in the tree.

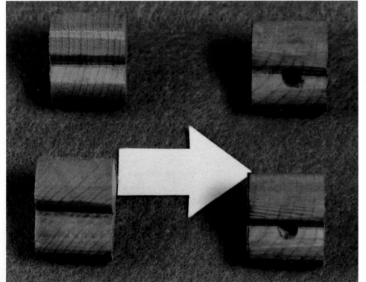

Finally, drill a 3/16" hole into the top of each heart, so a string can be inserted later. These holes should also be about 1/4" deep.

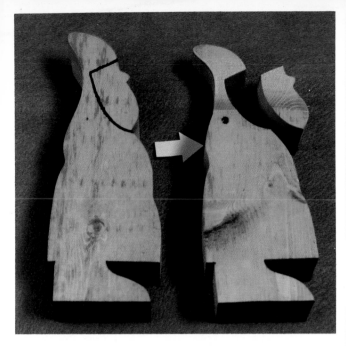

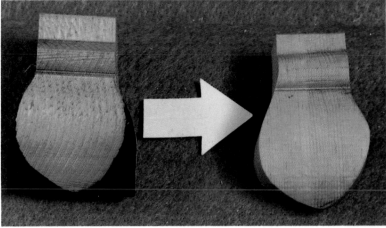

After sawing out the tapers, lay the body on its side, and sketch in the face and beard section as shown by the heavy dark line in the photo. Saw this entire section free from the body, following the heavy line.

On the section you just sawed from the body, sketch in the beard outline as shown. On later carvings, here is another area you can experiment with for different looks. You can leave the beard wide, or you can make a skinny beard. Your imagination and creativity are your only limitations. Your **main** objective is to have the face and beard narrower than the body, so when you put it back together later, the head will appear to be "inside" the hood.

Now, lay the face section on its back and saw away the darkened sections. (We are using the outlines you drew in the previous step as our sawing guide.)

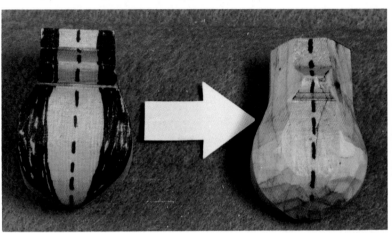

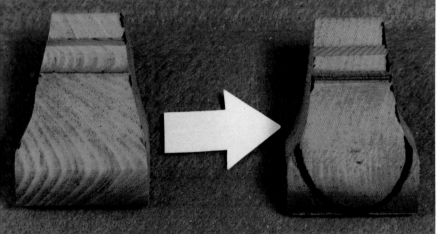

Before we begin carving the face detail, we need to shave off the sharp edges of the face and beard. We want to achieve a rounded look from the center of the face, around to the sides of the head. Sketch in a center line down the front of the face, to help you keep the left and right sides of the face in proportion as you round the edges. The darkened areas in the photo show the section of wood to be removed from each side of the face and beard. The other face in the photo shows how it should look after the wood is removed.

After completing the previous step, you now have some new sharp edges . Use your knife and shave these away. The two faces in the photo show the before and after results of this step. You should now have a fairly round and smooth face, and we are ready to begin detail carving on the face and beard.

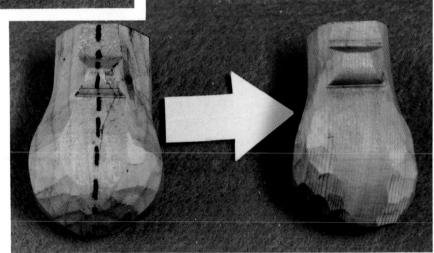

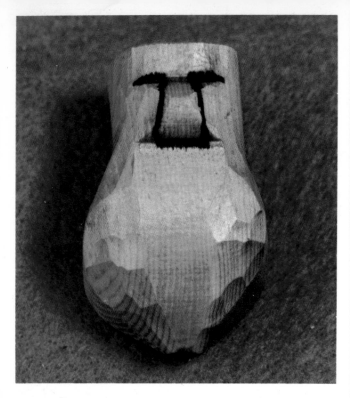

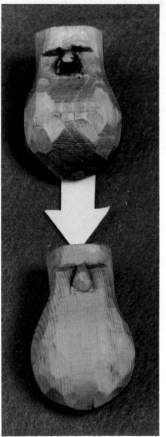

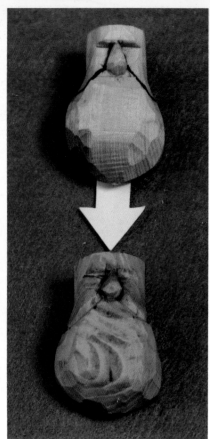

Sketch in the eye and nose lines as shown in the photo. To make eye sockets, and to create the nose, you will use the tip of your knife and incise the wood about 1/8" deep along the lines you drew. Make the cut a little deeper at the inside corners where the top of the eyes meet the top of the nose.

Let's do a bit more shaping on the nose. Draw a slanted line across the lower corners of the nose. Cut these off with your knife, then round off all the sharp edges. Santa should now have a nose he can be proud of.

After sketching in lines to show the beard and cheek separation, use your knife or a small "V" gouge to create a "v" channel along the lines you drew. Once the channel is made, use your knife to round off the sharp edges that were created when you made it.

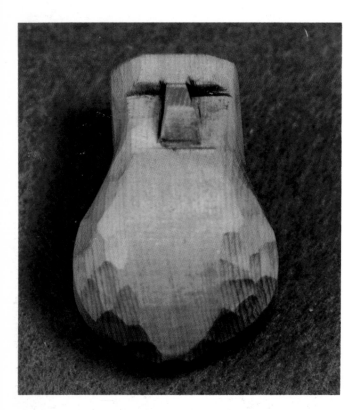

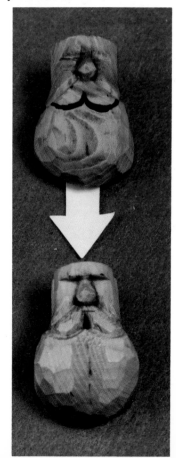

Starting at the tip of the nose, take your knife and "shave" up toward the eye. Make the cut deeper as you approach the top of the nose. Taking away more and more wood as you reach the top of the nose will make the nose stand out from the cheeks, and will also create eye sockets. Do this procedure for both sides of the nose.

Sketch in a moustache shape, and separate it from the beard using the "v" channel method, as in the previous step. Next, using a small nailset or small drill bit (a 1/8" bit seems to be about the right size), make a mouth hole for the pipe.

8

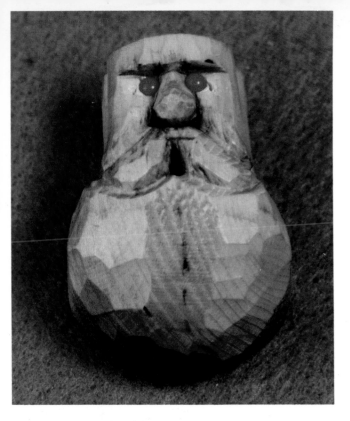

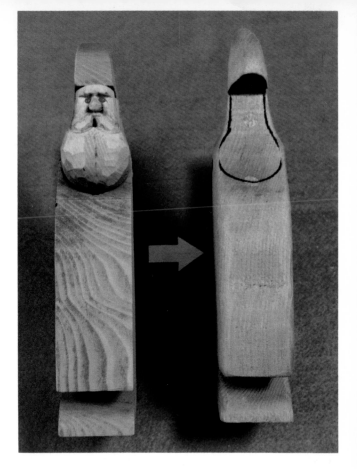

This step is optional. You may leave the eye sockets as they are, or you may want to use the quilt pin method to make eyeballs. Refer to the directions in the front of the book to refresh your memory on using the quilt pins to make eyeballs. The photo shows a face with the pins inserted, and also how the eyes look with the triangular pieces of wood removed from the corners of the eyes. **NOTE:** I normally use pins with a WHITE head for the eyes, but to help you to see what we are doing, I have used pins with a RED head.

At this point, we are finished with the face and beard for this project. Experienced carvers may want to add more detail to the beard and mustache using a gouge or "v" tool. To finish the head, and prepare it for gluing back onto the body later, put a small amount of wood glue on the back side of the head, and rub it into the wood with your fingertip. This will seal the wood and will make a stronger joint, when we assemble all the pieces.

After the back of the head is dry (a couple of minutes), place, **but do not glue**, the head back onto the body. With a pencil, lightly trace the outline of the face and beard onto the body. This will give you a reference so you don't cut into this area during this step. Remove the head and put it aside so you don't accidentally give Santa a "shave and haircut" while rounding off the sharp edges on the body.

Take your knife and round off all the sharp body edges. Next, use sandpaper and sand the entire body. We want a totally smooth finish, and all the sharp edges should now be gently rounded off. Once you are satisfied with the body, rub a small amount of wood glue in the hood area (inside the outline of the head you made earlier), so this area will be sealed also. This will give a good surface to glue the head to later.

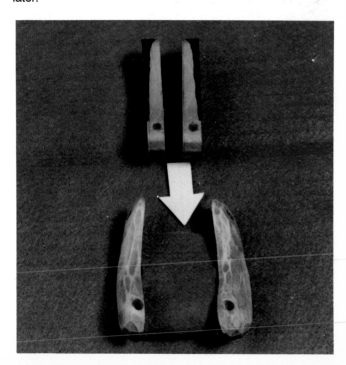

Round off the outside edges of the right arm with your knife, then do the same for the left arm. Next, use your knife and taper both arms toward the end which will attach to the body later. Finish the rounding with sandpaper to smooth out the knife cuts. The darkened areas in the photo show how the taper should look.

9

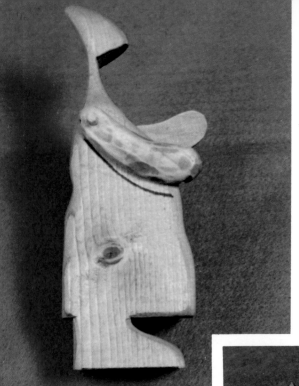

Left: Now, insert a section of 3/16" dowel through the arm holes in the body. You will want about 1/2" of dowel to protrude from each side of the body. Cut the dowel to the appropriate length, place the arms on the dowels and slide them against the body. Decide on the position you want the arms to be in. This is your choice, and most of the time will be determined by what you are going to have Santa holding in his hands. Once you have the arms where you want them, lightly trace around the edges of them with a pencil, to establish some reference lines on the body.

Right: We also want to round the sharp edges on the tree and hearts. Use your knife as before, then follow with sandpaper for final smoothing. **Take care when rounding the hearts.** (The fingers holding the heart will be very close to the knife blade while you are rounding the edges).

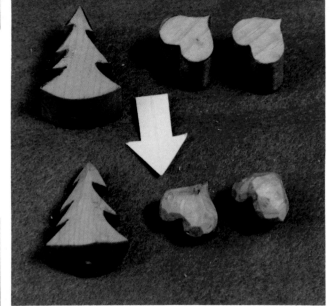

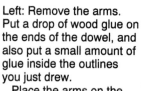

Above: Next, use your knife and **lightly** trim off the sharp edges of the pipe, then follow with a light sanding. Now cut off the "handle", so that only the pipe remains. Test fit the pipe stem in the hole in Santa's mouth. If the stem is too long, or too big to fit into the hole, trim it accordingly until you get a look you are happy with. When you are satisfied, remove the pipe. Put a drop of glue in the hole and insert the pipe. Lay the head and pipe assembly aside to dry.

Left: Remove the arms. Put a drop of wood glue on the ends of the dowel, and also put a small amount of glue inside the outlines you just drew.

Place the arms on the dowels, and slide them firmly against the body. Hold them in place for about 30 seconds to allow time for the glue to begin setting up to form a good joint.

Put the body aside to allow the glue time to dry. Later, use your knife to trim the dowels flush with the outside surface of the arms. After trimming the dowel, sand the area smooth if necessary.

Right: Now, insert (but don't glue yet), a short piece of 3/16" dowel into the base of the tree. Slide this "tree trunk" into the left or right hand hole (your choice), so the bottom of the tree rests against the top of the hand. Mark a line on the dowel about 1/2" below the bottom of the hand. Remove the tree and dowel. Cut the dowel off where you marked it. Glue one end of the dowel into the tree, and set it aside to dry.

This completes the carving. Now we need to paint all the pieces and put Santa back together.

painting the project

Before you begin painting the face and beard, insert a quilt pin into the back of the head, so you will have a "handle" to hold onto while painting. Using a FLESH color, paint the face area. While the paint is still damp, put a small dab of BLUSH on the cheeks and tip of nose. With a clean, dry brush, swirl and blend the BLUSH into the FLESH, so the cheeks and nose appear to have a weathered and wind-burned look. This will become easier, the more you do it.

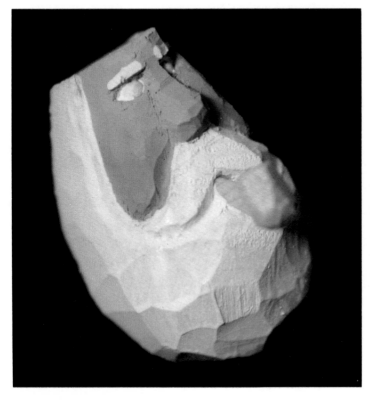

Paint the beard and eyebrows WHITE. If you didn't use the pin method for eyes, also paint a small WHITE line in the crease of the eye socket, to simulate the eyeball. If you used pins, paint the pin head WHITE.

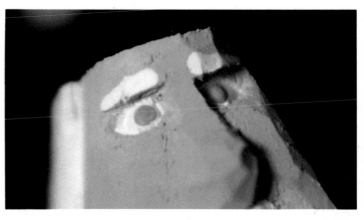

Now take a small, fine-tip brush and put a round dot of LIGHT BLUE in the center of the eye.

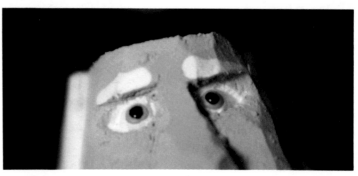

When this is dry, use your fine-tip brush to put a BLACK dot inside the BLUE dot. The placement of the BLUE and BLACK dots will have various effects on Santa's facial expression. Experiment on a piece of scrap wood to discover all the expressions you can create. I personally like to show the eyes rolled upward, looking toward one side or the other. You may experiment with different looks and find one that you prefer also.

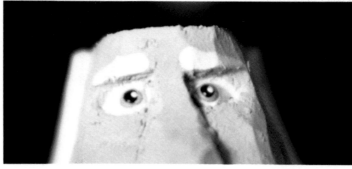

Finally, take a toothpick and put a WHITE highlight on the edge of the BLACK dot. If the eyes are looking to the left, I put the highlight around the 10 o'clock position. If looking to the right, I put the highlight around the 2 o'clock position. When looking straight ahead, as they are here, you can put the highlight at either the 10 o'clock or 2 o'clock position, whichever you prefer. This is another area you can experiment with on a scrap piece of wood, to see the effects of moving the highlight around.

Paint the pipe BROWN. Lightly dry-brush a small amount of BLACK around the top of the bowl, to give it a burned and well-smoked look.

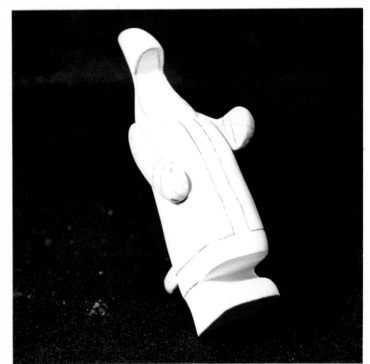

As an aid in painting the body, we need to lightly sketch in some guidelines before painting. We need to define the mitten and fur separations on the arms, and the boot separation and fur lines on the body. (Don't worry if you carry the fur line too far up the front of the body. Once the head is glued in place, you will only see the fur that extends below the beard).

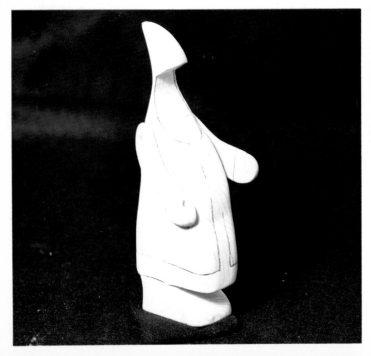

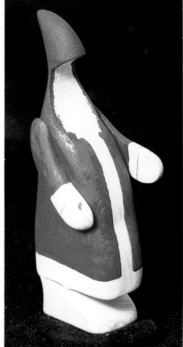 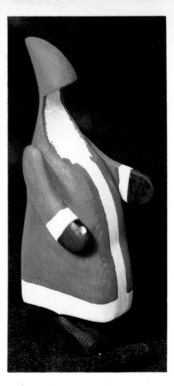

Paint the hood, robe and arms RED.

Finally, paint the boots BLACK. You may paint the mittens BLACK or GREEN, or a color of your choice. I normally paint them BLACK.

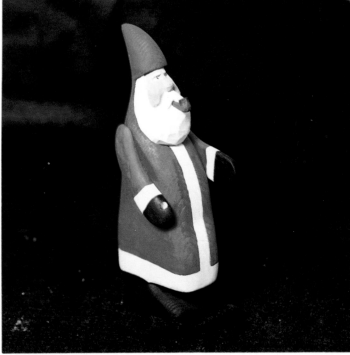

When the body and face sections are dry, remove the pin, put a small dab of wood glue on the back of the head, and glue it in place. **Take care to ensure that the face is centered inside the hood area as you press it into place.** Put this aside to dry while you paint the tree and hearts.

Now, paint all the fur areas ANTIQUE WHITE. If you make it a practice to always paint your light colors first, any mistakes or accidents will be covered over by the darker colors you paint later.

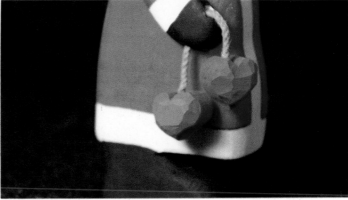

Cut two short pieces of 3/16" dowel and insert (don't glue) them into the holes in the hearts. They will act as "handles" while you paint the hearts. Use a DARK RED and paint the hearts. This darker color will make the hearts stand out against the RED of the body. Set the hearts aside to dry.

Let the heart hang about 1" below the hand. Cut the string so that when the other heart is attached, it will also hang down about 1". These measurements are not critical. You can make the string any length you prefer, if it looks good to you. Glue the other heart to the cut end of the string.

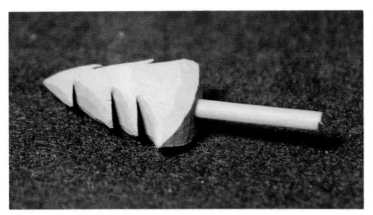

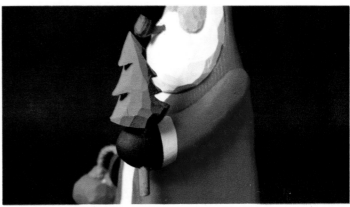

Paint the tree DARK GREEN. When that is dry, paint the trunk LIGHT or MEDIUM BROWN. Set the tree aside to dry.

Now, put a small dab of glue on top of the empty hand. Slide the tree trunk through the hole and let the tree rest against the top of the hand. Set the project aside to dry.

When everything is dry, sign your name, and put the date on the bottom of the carving. After you become a famous carver, your signature will make your carvings more valuable. I also number my carvings, and include this number along with my signature and date. I keep a record book of sequential numbers, along with a brief description of the carving. Many times, collectors will not buy a carving unless it has a signature and a number. As your carvings become more and more "collectible", the lower numbered ones will increase in value to collectors. Your carvings are a reflection of your talent and skill... be proud of that, and put that signature on there so the whole world will know who made that master-piece! Take a few minutes now to sit back and admire your creation.

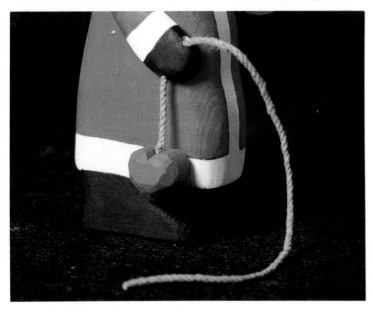

Take piece of twine or heavy string and insert it through the hand that is not going to hold the tree. Remove the dowels you used earlier as handles while painting the hearts. Put a small drop of glue in the hole in one of the hearts, and push the string into the hole. You may have to use a small nail to "coax" the string into the hole. Allow the glue to dry for a few minutes.

gallery and study models

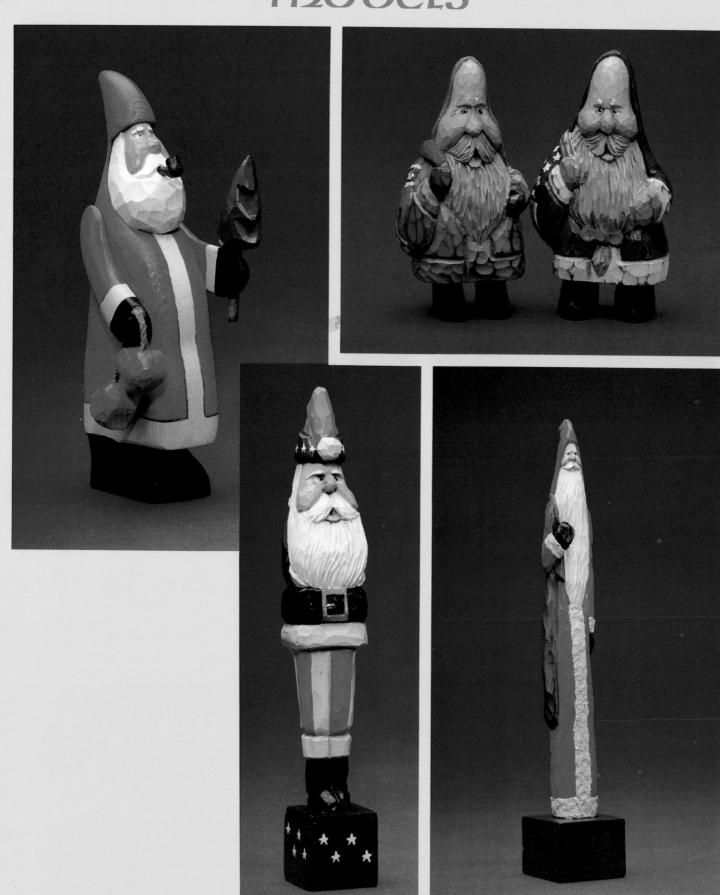

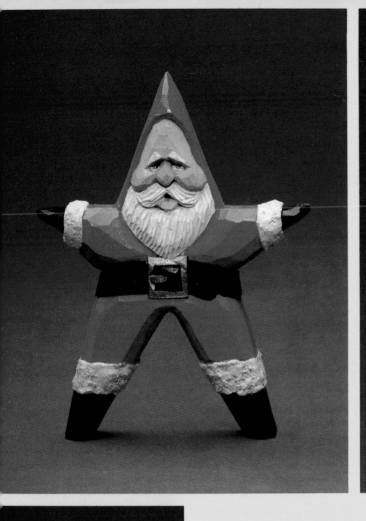

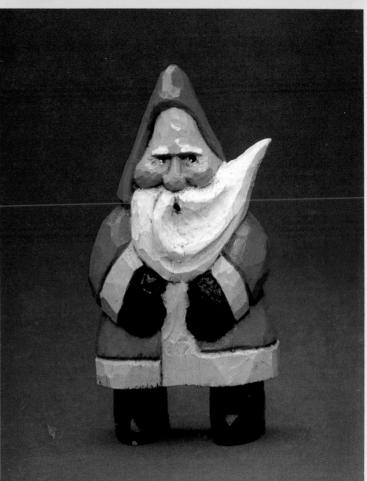

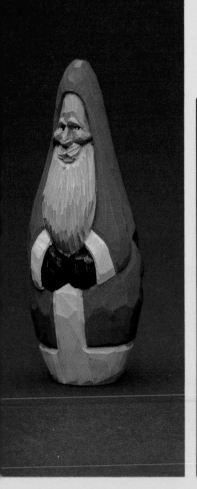

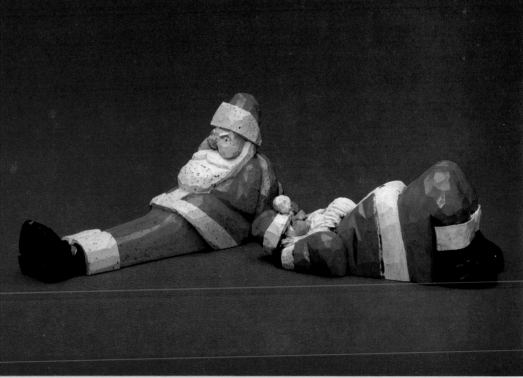

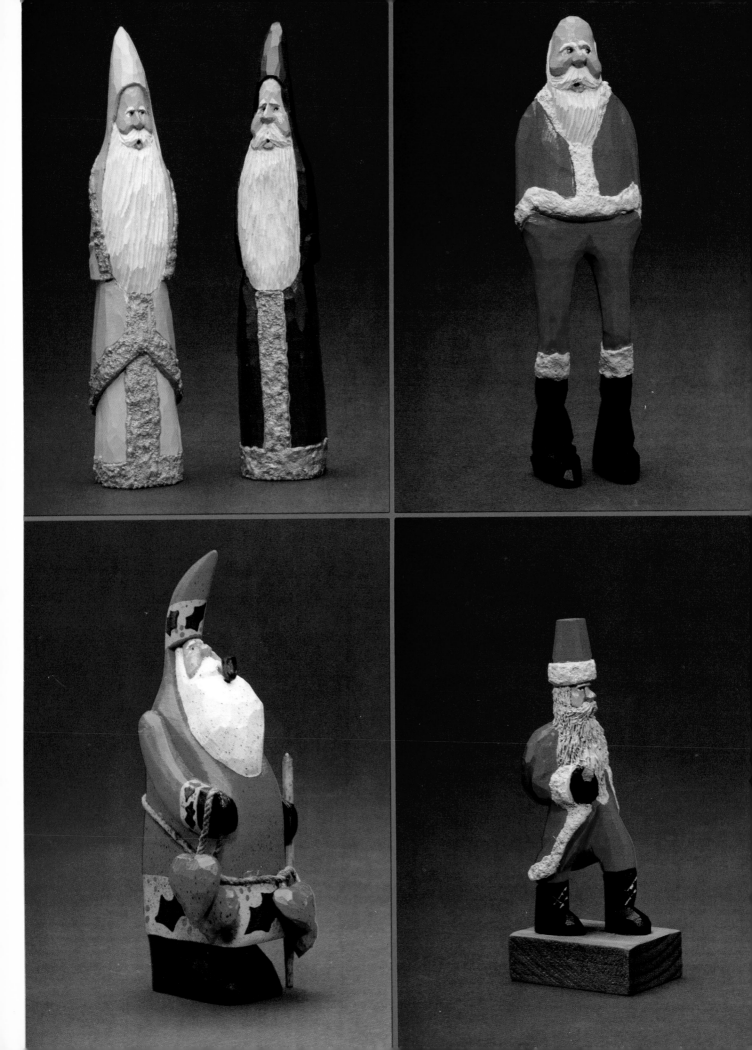

carving project pattern

carving project santa

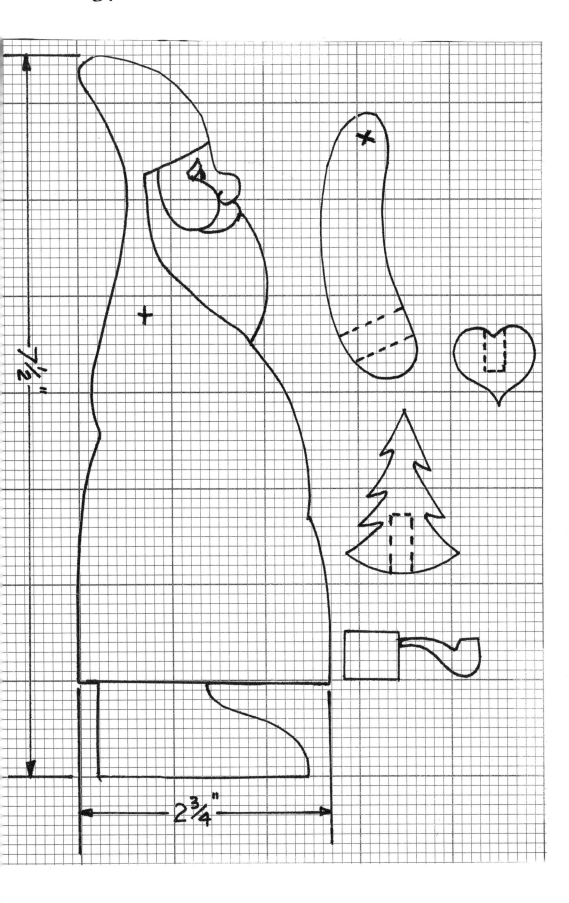

$7\frac{1}{2}$"

$2\frac{3}{4}$"

Pattern full size.

supplemental project patterns

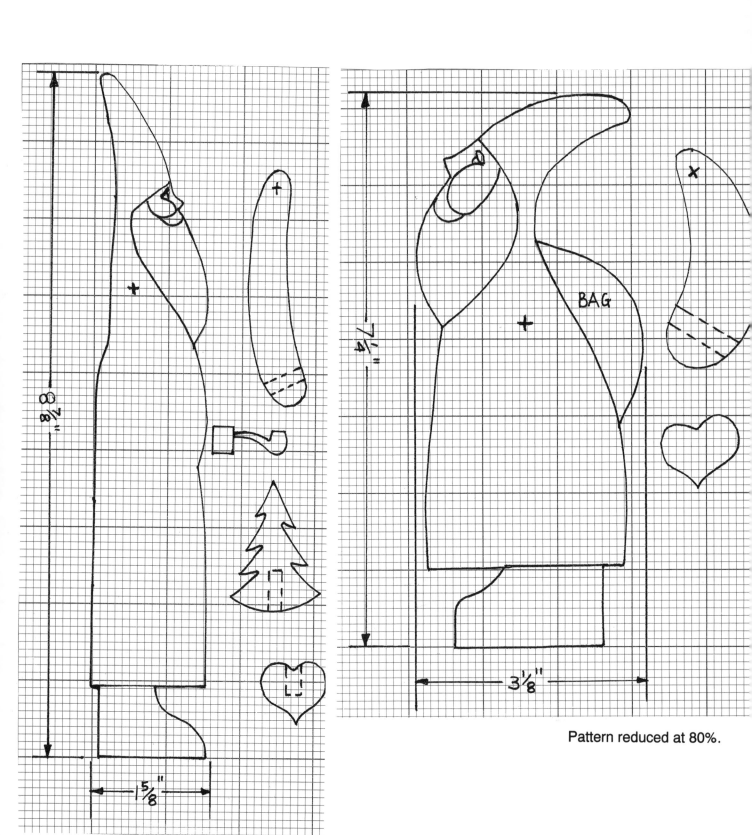

BAG

$3\frac{1}{8}$"

$7\frac{1}{4}$"

Pattern reduced at 80%.

$2\frac{7}{8}$"

$1\frac{5}{8}$"

Pattern reduced at 80%.

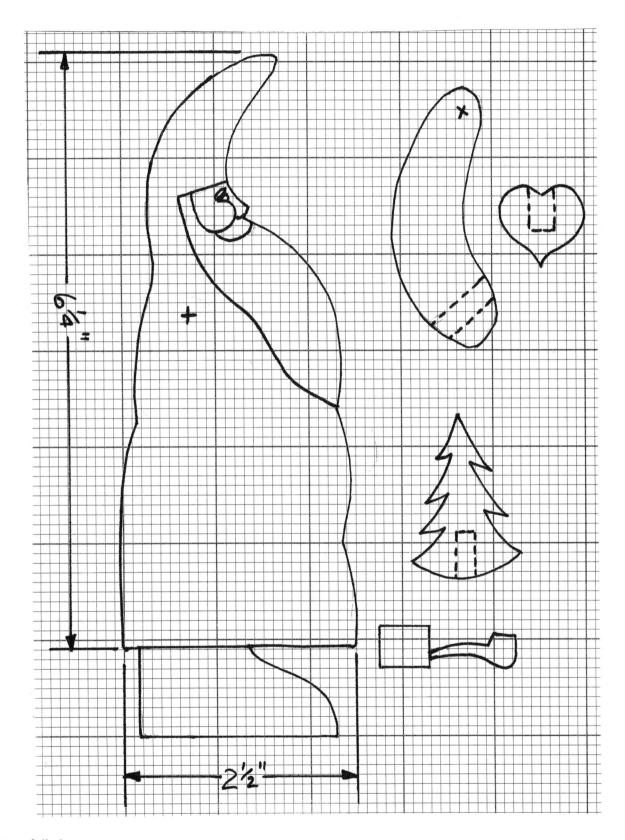

6¼"

2½"

Pattern full size.

additional patterns

walking santa

Carve walking stick separately. Adjust to length and glue in
hand.

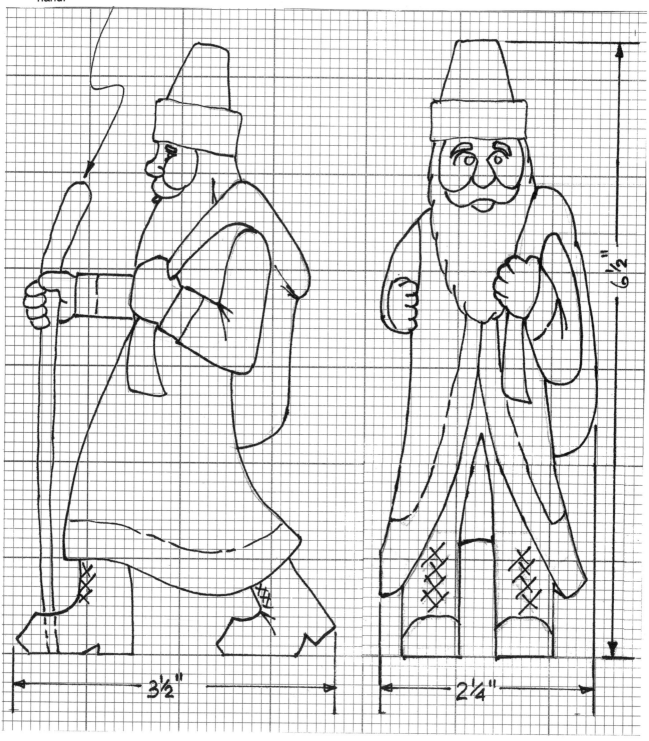

3½"

2¼"

6½"

Walking stick: Autumn Brown, or stain with Wal-
 nut, etc.
Boots: Black with Gold laces (see X's on boots)
Hands: Flesh..or you can carve them as mittens. If
 mittens, paint them Avocado or Black.

Pattern full size.

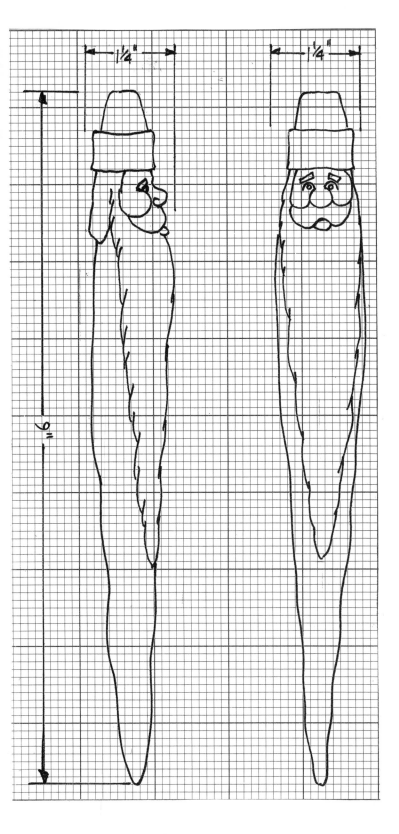

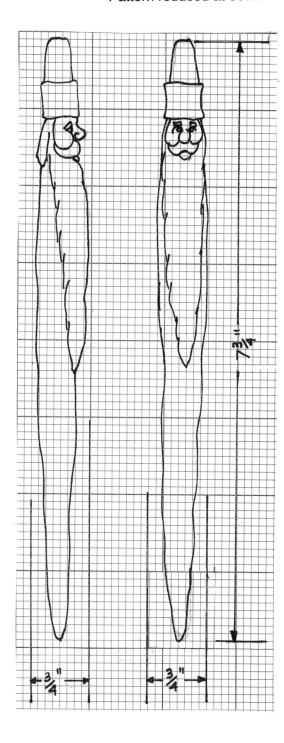

Pattern reduced at 80%.

Insert a screw eye hook in top of the head and hand it from the tree or mantel.

Main part of icicle: Red, or Antique White/Light Grey.

Pattern reduced at 80%.

ice skating santa

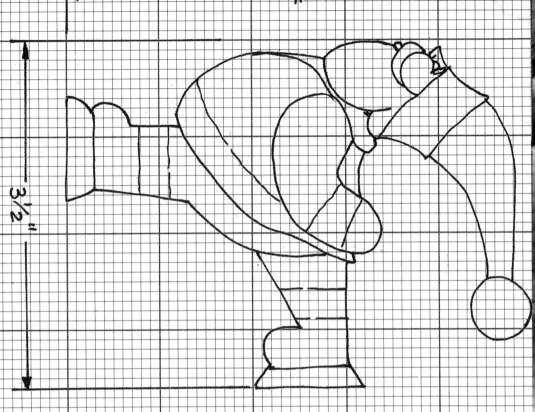

Pattern reduced at 80%.

Pattern reduced at 80%.

Mittens: Avocado or
 Black
Buttons on coat: Gold or
 Black
Ice skates: Silver or
 metallic Grey

chubby santa

Pattern reduced at 80%.

Legs: White, with horizontal or
 vertical Red or Green
 stripes.
Wooden shoes: Antique Gold
Buttons on coat: Gold or Black

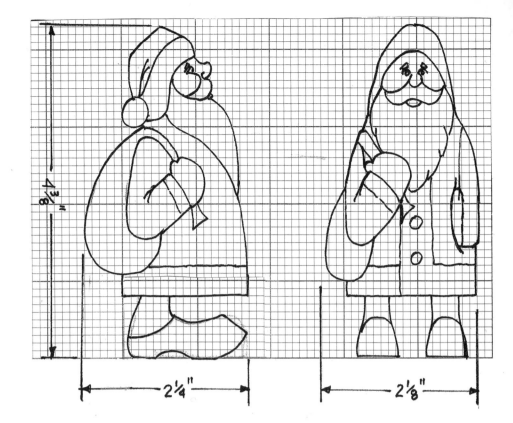

man-in-the-moon santas

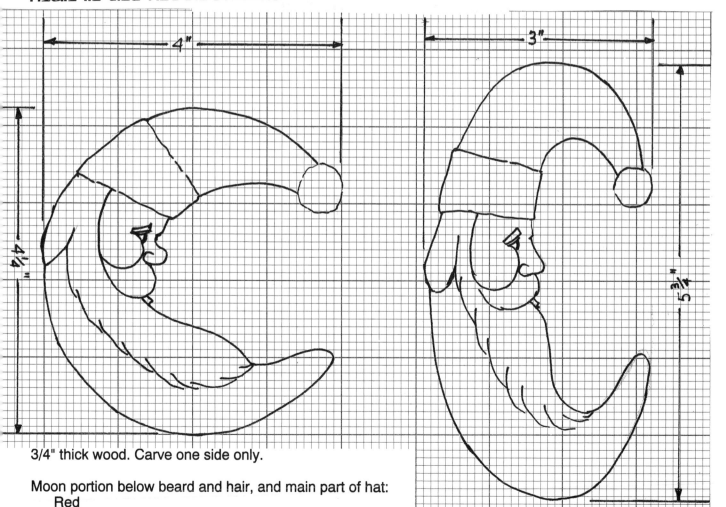

3/4" thick wood. Carve one side only.

Moon portion below beard and hair, and main part of hat:
 Red
Fur around hat, and ball on tip of hat: Antique White
To use as a hanging ornament, put a small screw eyehook
 in the top of the carving and put a string loop through it.

Pattern reduced at 80%.

northern (union) santa

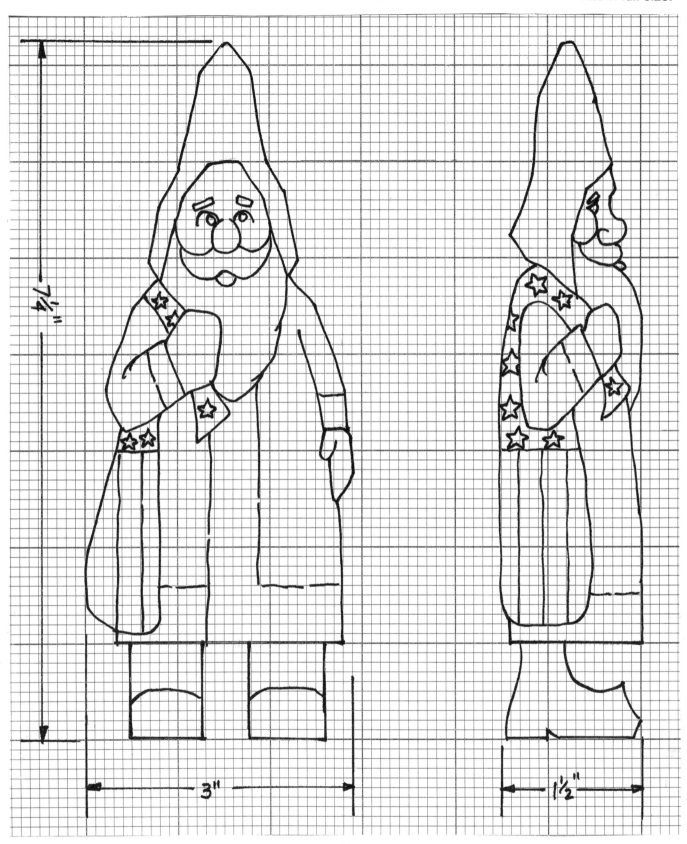

7¾"

3"

1½"

Hood and main part of robe: Liberty Blue
Fur: Antique White
Bag: Upper portion, Prussian Blue with White stars.(Use a different shade of blue so it will contrast with the
 robe color).
Lower portion: Red and White stripes.
Mittens: Black

24

southern (confederate) santa

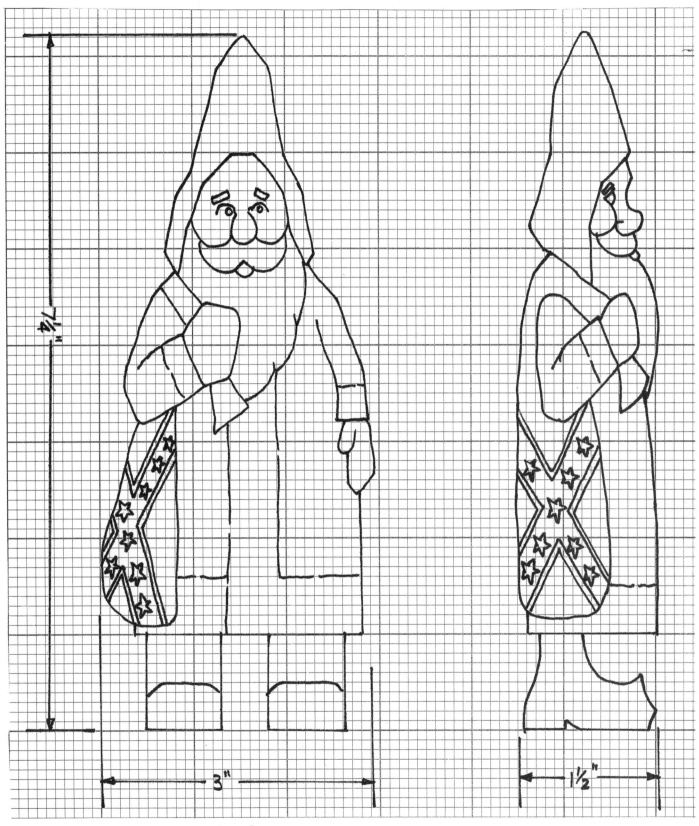

Hood and main part of robe: Lichen Grey
Fur: Antique Gold
Bag: Center stripe is Prussian Blue with White
 stars.Small stripe along outside of main stripe
 is White.Main part of bag is Red.
Mittens: Black or Antique Gold

Pattern full size.

sitting santa

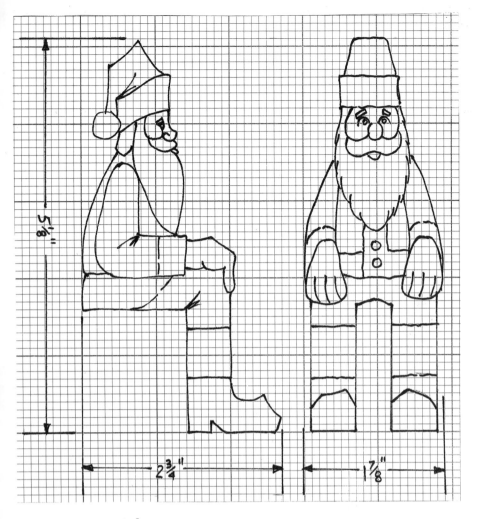

Sitting Santa for shelf or fireplace
mantel.

Mittens: Black or Avocado
Buttons on coat: Gold or Black

Pattern reduced at 80%.

santa with candy Bag

Candy Canes: White with
Green or Red stripes.

Pattern reduced at 80%.

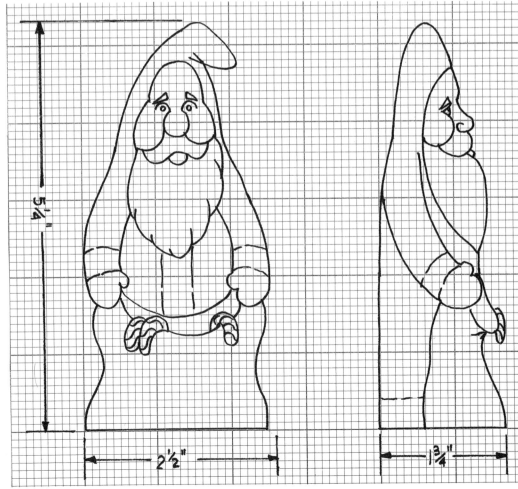

Roly-poly santa

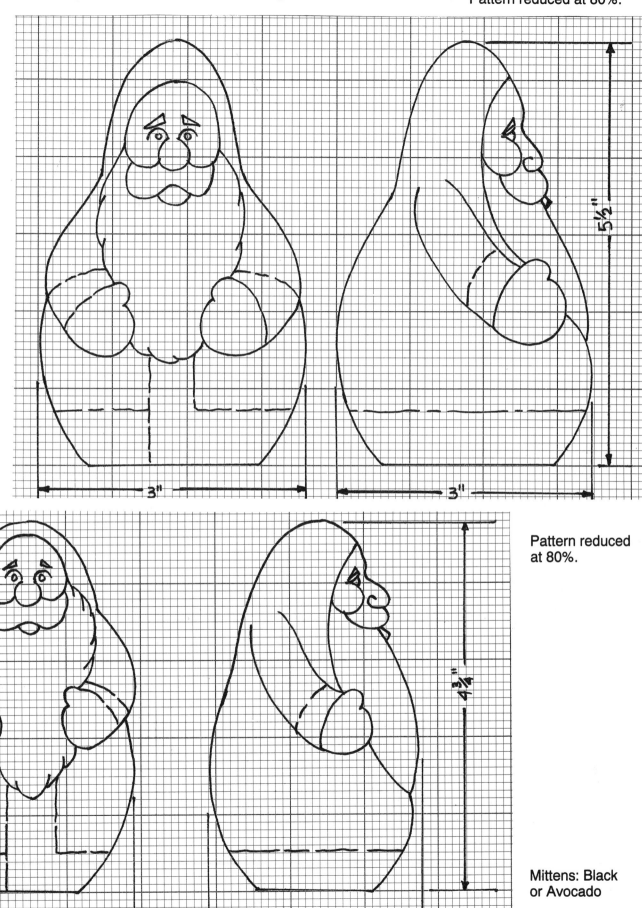

5½"

3"

3"

3¾"
4¼"

3"

3"

Mittens: Black
or Avocado

stAR santA

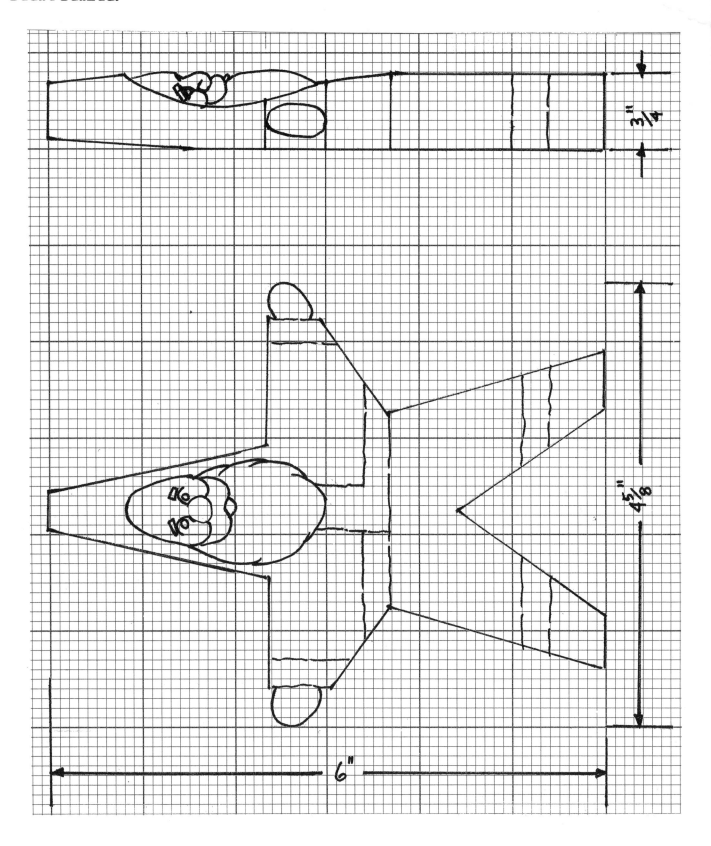

Mittens: Black or Avocado

Pattern full size.

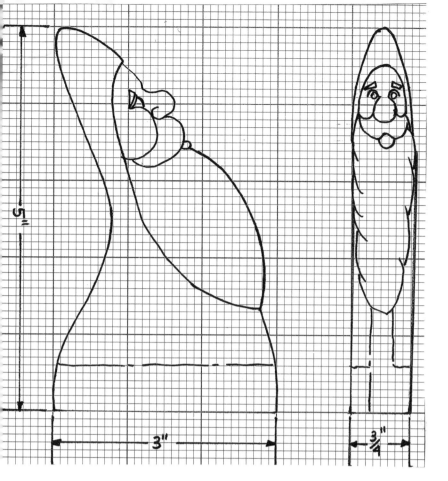

free-style santa

Pattern reduced at 80%.

5"

3"

3/4"

"shorty" santa

Pattern reduced at 80%.

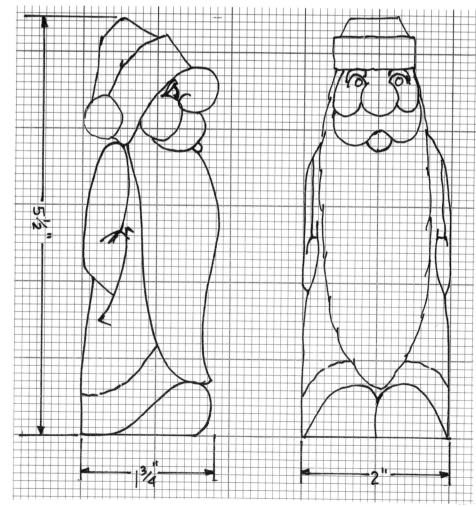

5½"

1 3/4"

2"

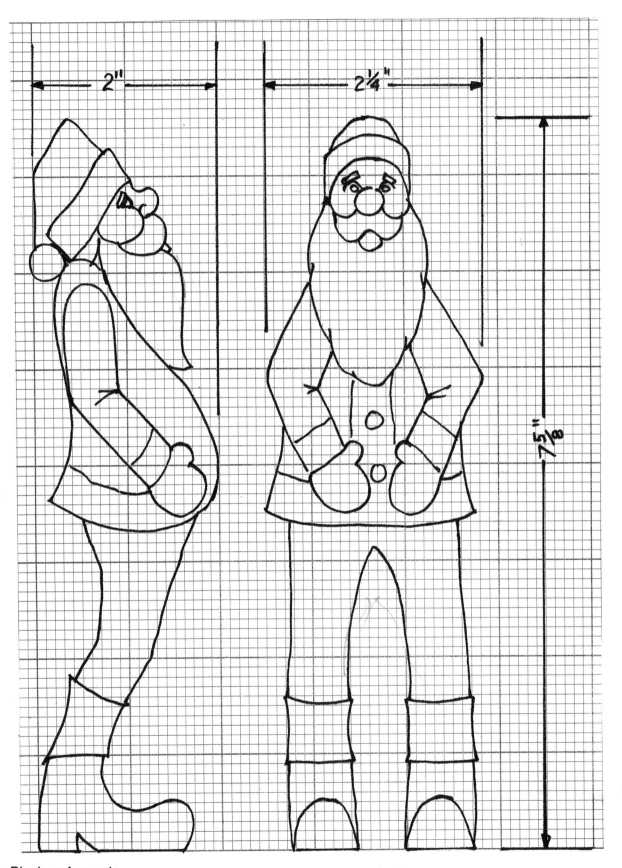

2"

2¼"

7 5/8"

Mittens: Black or Avocado
Buttons on coat: Gold or Black

Pattern full size.

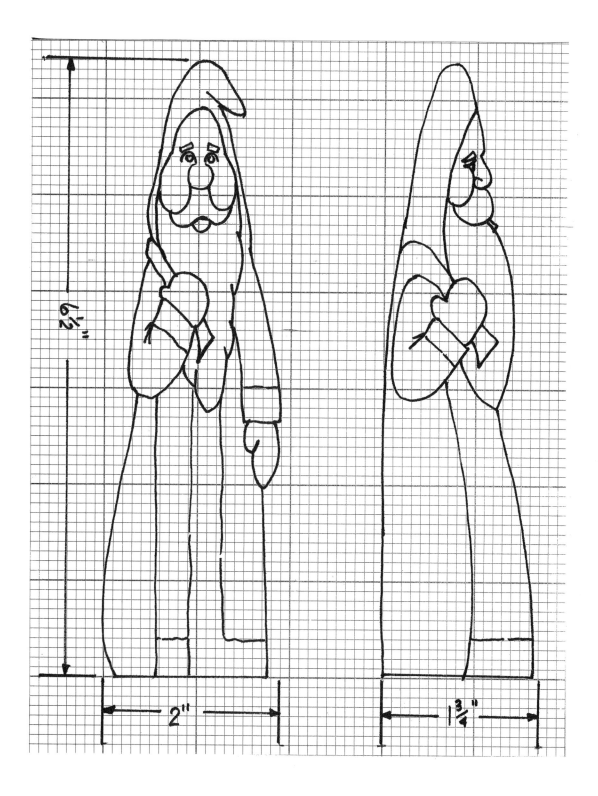

6½"

2"

1¾"

Mittens: Black or Avocado

Pattern full size.

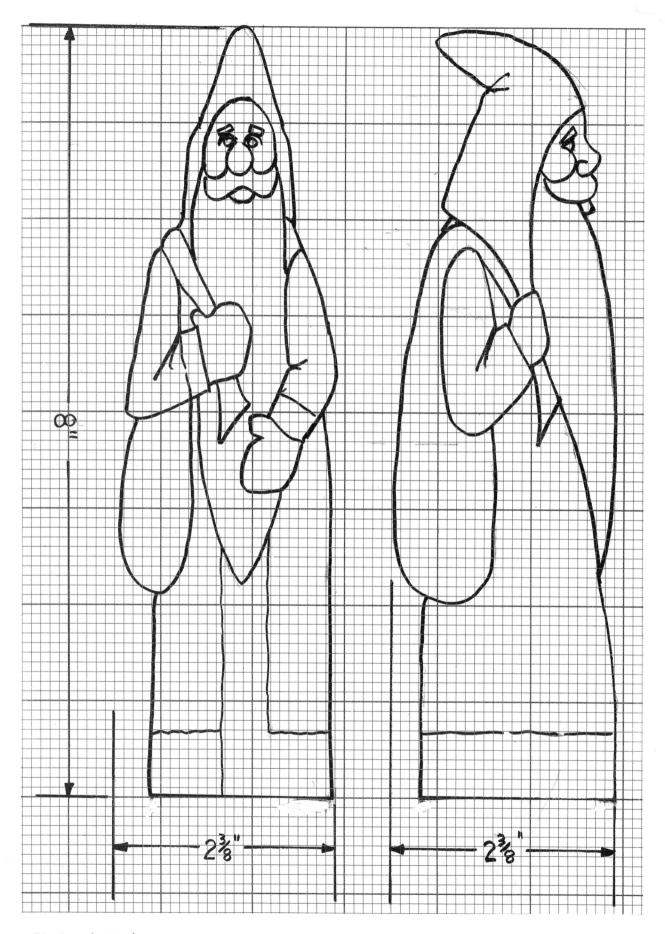

8"

2⅜"

2⅜"

Mittens: Black or Avocado

Pattern full size.

Pattern full size.

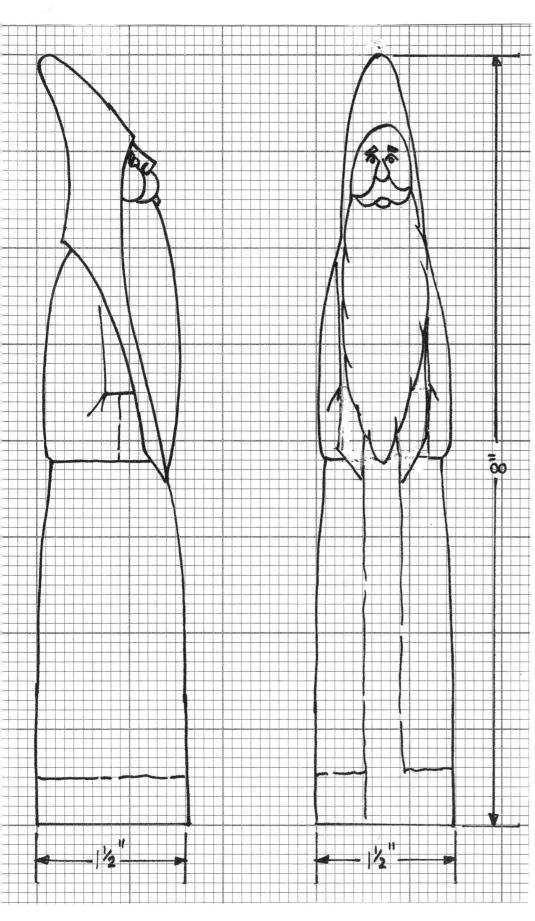

1½"

1½"

Mittens: Black or Avocado

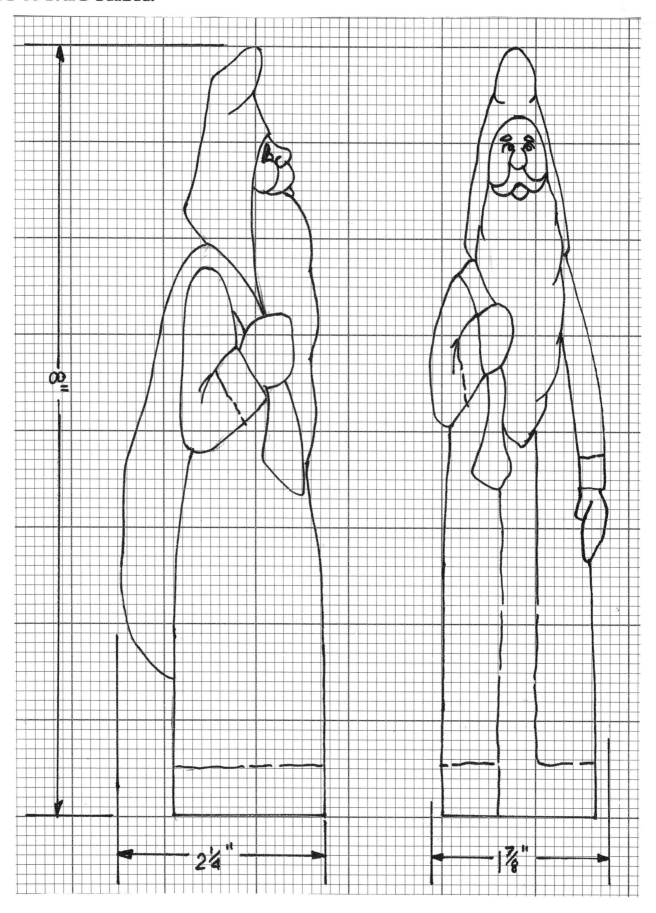

8"

2¼"

1⅞"

Mittens: Black or Avocado

Pattern full size.

fishing santa

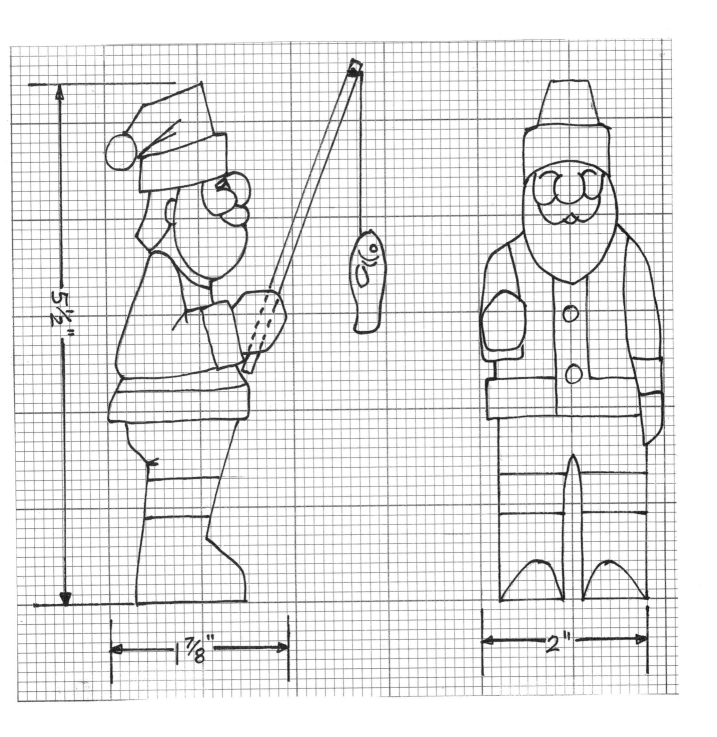

Pole: Brown or Black
Mittens: Black or Avocado
Fish: White belly; Green sides and top; Brown eye with Black dot in centerDrill a 1/8" hole through hand to hold pole. Use a piece of 1/8" dowel for the pole. Use a piece of Black thread to attach fish to pole.

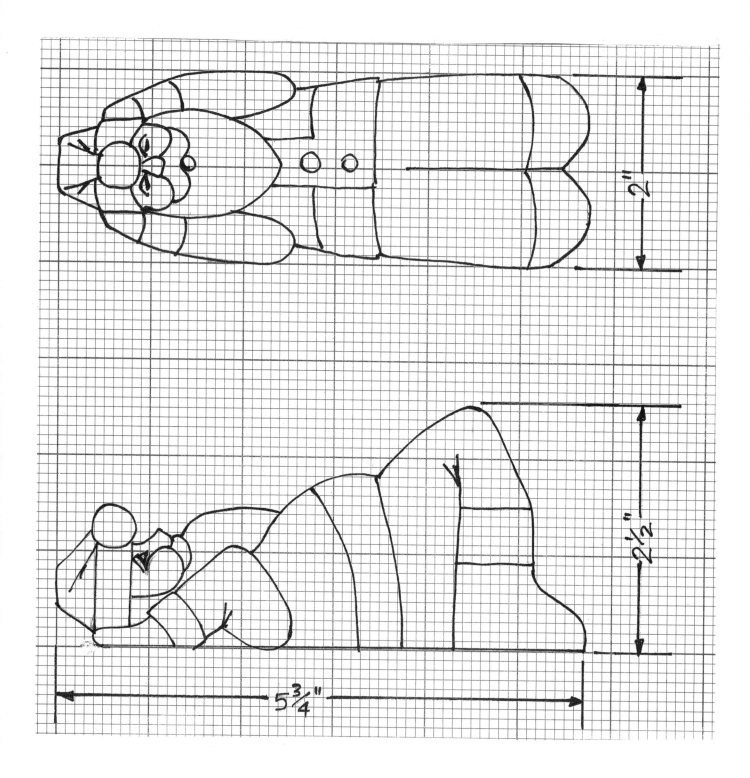

2"

2¹⁄₂"

5³⁄₄"

Buttons on coat: Gold or Black
Mittens: Black or Avocado

Pattern full size.

Pattern full size.

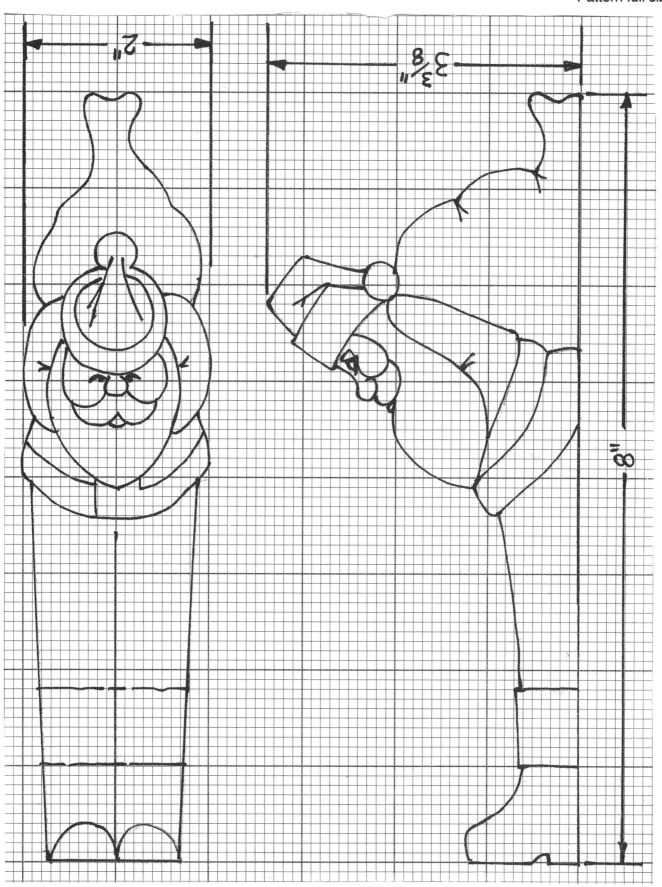

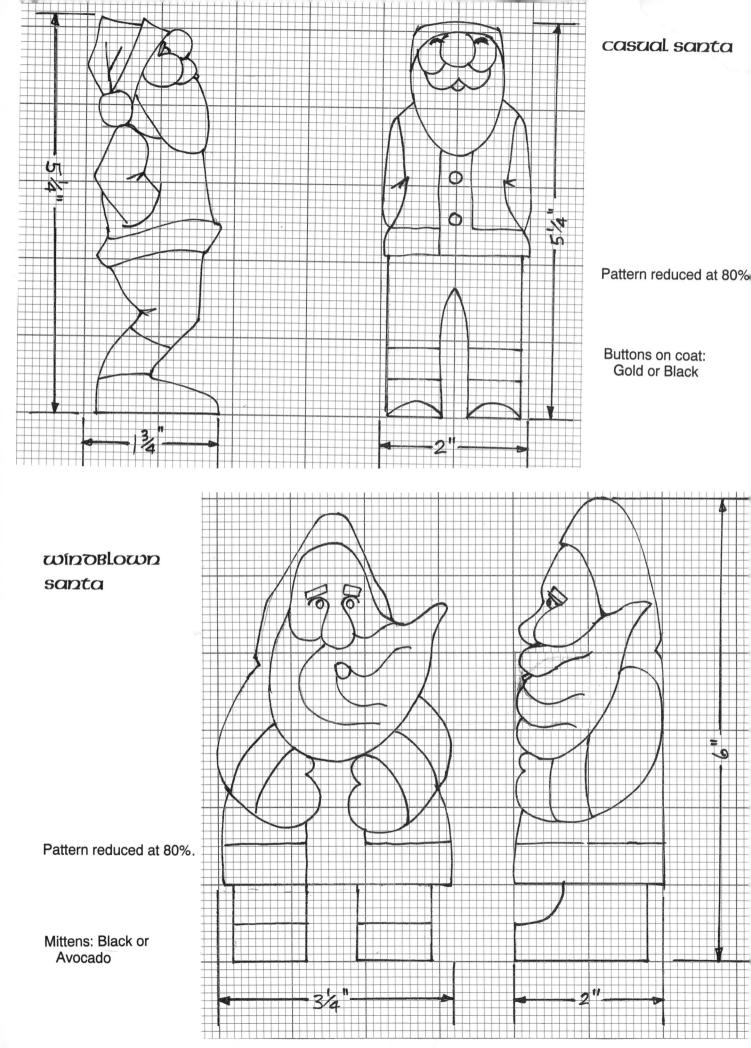

casual santa

5¼"

5¼"

3/4"

2"

Pattern reduced at 80%

Buttons on coat:
Gold or Black

windblown
santa

Pattern reduced at 80%.

Mittens: Black or
Avocado

6"

3¼"

2"

Pattern full size.

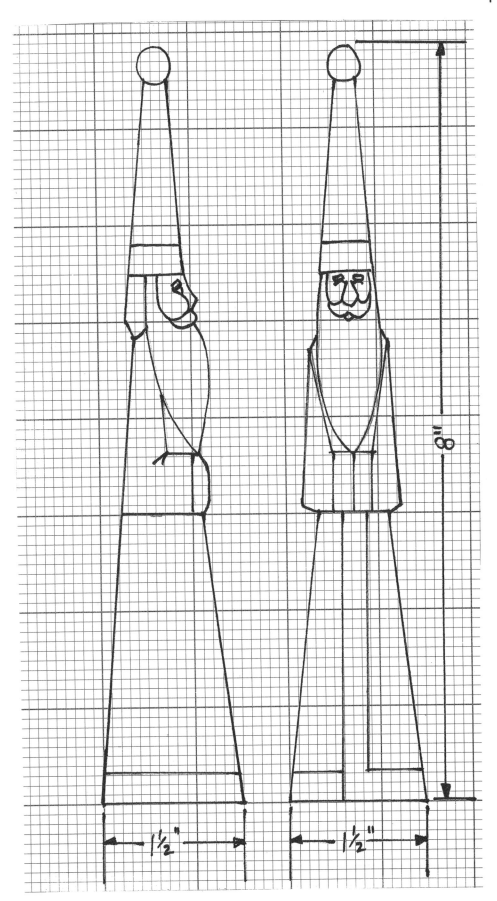

8"

1½" 1½"

western santa

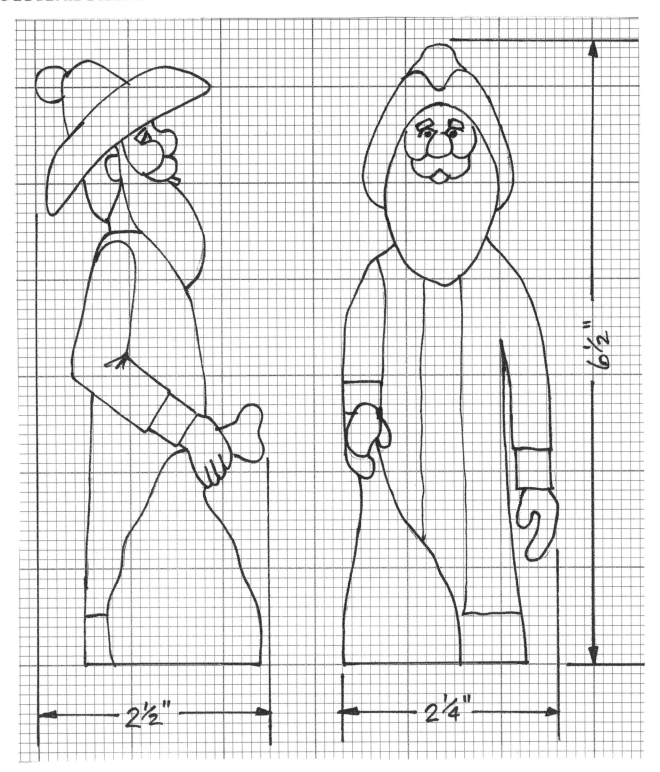

2½"

2¼"

6½"

Hat: Red, with Antique White ball
Coat: Red, with Antique White fur
Hands: Flesh

Pattern full size.

Pattern full size.

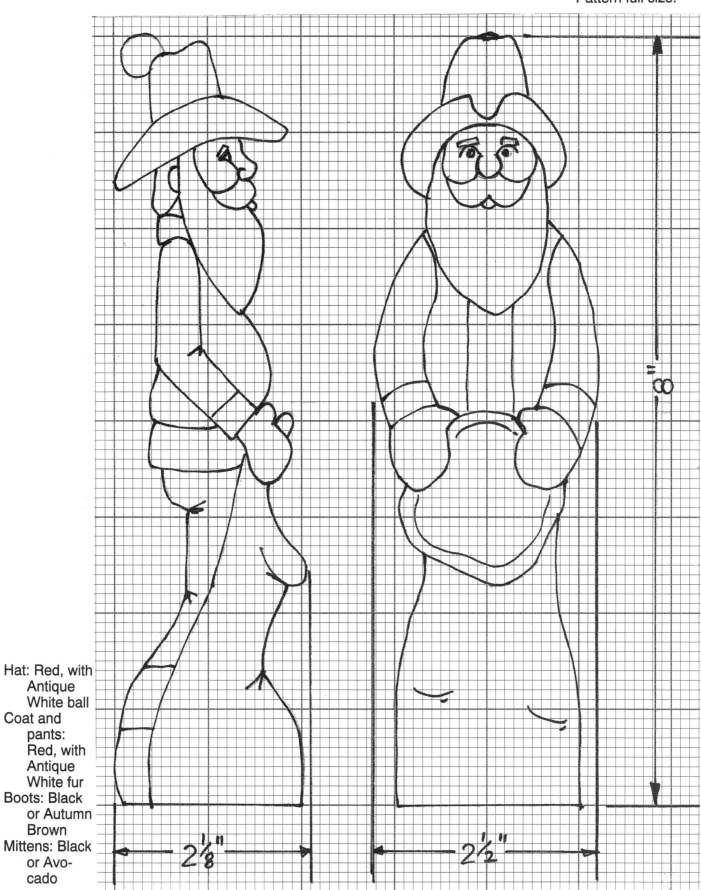

8"

Hat: Red, with
 Antique
 White ball
Coat and
 pants:
 Red, with
 Antique
 White fur
Boots: Black
 or Autumn
 Brown
Mittens: Black
 or Avo-
 cado

2⅛"

2½"

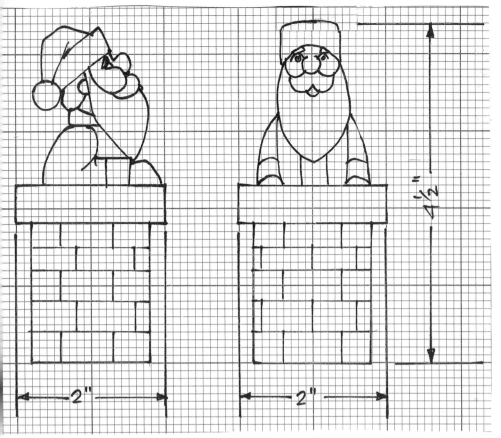

chimney santa

Pattern reduced at 80%.

Chimney rim: Quaker Grey
Bricks: Red
Cement between bricks: Quaker Grey
Mittens: Black or Avocado

chimney santa

Pattern reduced at 80%.

Chimney rim: Quaker Grey
Bricks: Red
Cement between bricks: Quaker Grey
Mittens: Black or Avocado
Buttons on coat: Gold or Black

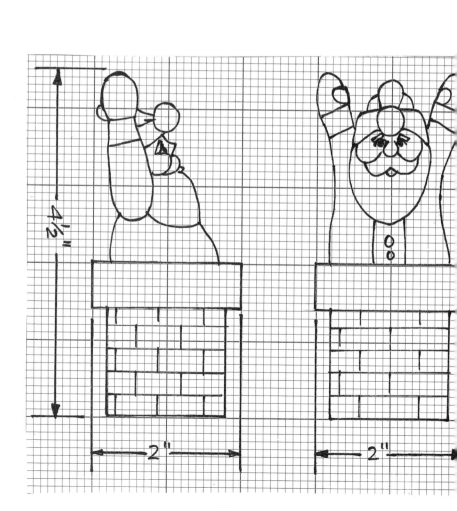

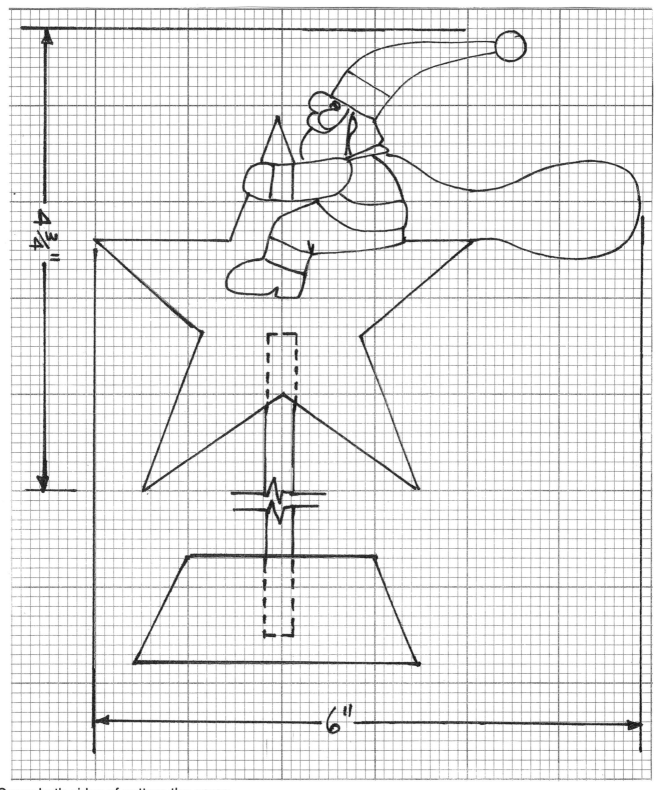

4 3/4"

6"

Carve both sides of pattern the same.

Drill a 1/4" hole in star and base to accommodate a 1/4" dowel. Cut 1/4" dowel about 4" long to connect star to base.

Make the base a size and shape of your choice, but large enough to provide a stable support for the star rider.

Star: Antique Gold

Dowel and base: stain a color of your choice (Mahogany, Walnut, etc.)
Mittens: Black or Avocado

weathervane santa

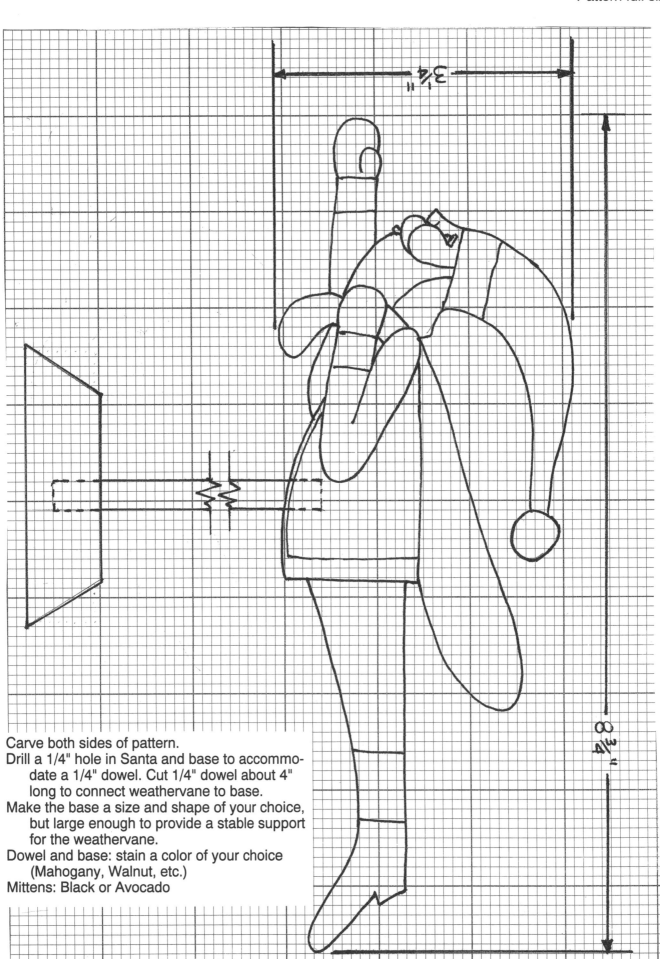

3¼"

8¾"

Carve both sides of pattern.
Drill a 1/4" hole in Santa and base to accommo-
 date a 1/4" dowel. Cut 1/4" dowel about 4"
 long to connect weathervane to base.
Make the base a size and shape of your choice,
 but large enough to provide a stable support
 for the weathervane.
Dowel and base: stain a color of your choice
 (Mahogany, Walnut, etc.)
Mittens: Black or Avocado

Bungee Jumper Santa

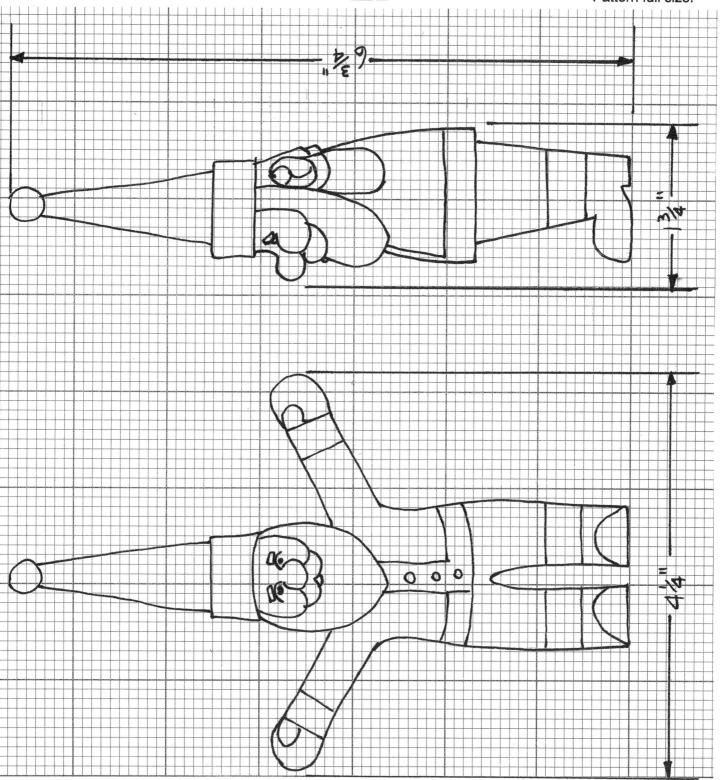

Mittens: Black or Avocado
Buttons on coat: Gold or Black
Put small eye screw in ball on top of hat. Attach a short length of elastic string or cord to eye screw.
Hang from mantle or doorway. A slight pull on Santa's feet will start him bouncing.

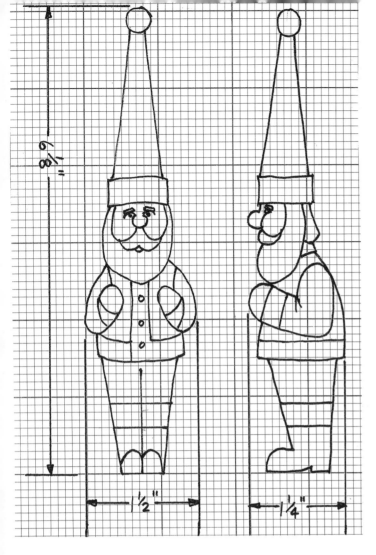

Bungee Jumper Santa

Pattern reduced at 80%.

Mittens: Black or Avocado
Buttons on coat: Gold or Black
Put small eye screw in ball on top of hat. Attach a
short length of elastic string or cord to eye
screw.
Hang from mantle or doorway. A slight pull on
Santa's feet will start him bouncing.

wake me later santa

Pattern reduced at 80%.

Mittens: Black or Avocado
Buttons on coat: Gold or Black

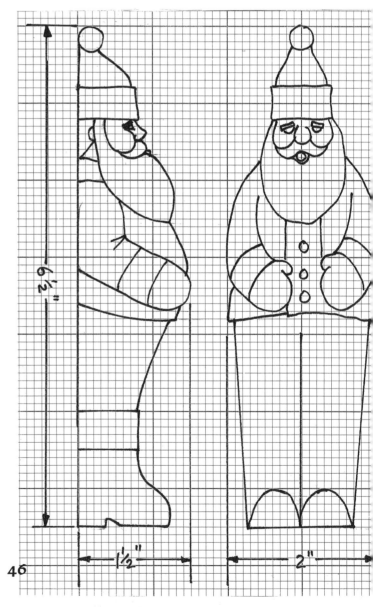

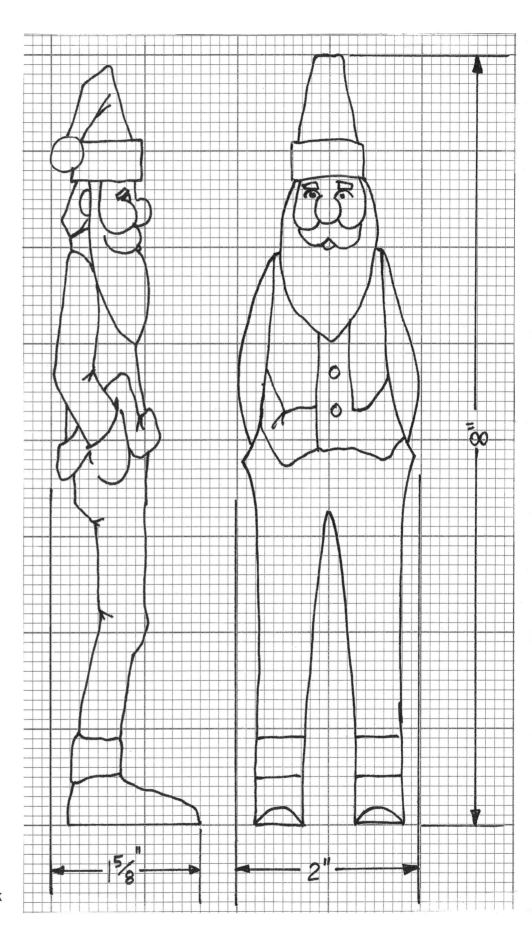

Pattern full size.

Buttons on coat: Gold or Black

Pattern full size.

Hat: Liberty Blue fur
 with White stars;
 Top of hat is Red:
 Ball on hat is
 White
Coat: Liberty Blue
 with White fur trim
 on sleeve cuffs
Belt: Black, with Gold
 buckle
Pants: Red and White
 stripes
Boots: Black, with
 White fur trim at
 top
You may want to
 make a base for
 this project, to
 give it stability so
 it will stand easily
 without tipping
 over. Make a size
 and shape of your
 choice.
Paint or stain the
 base a color of
 your choice.
 When the paint or
 stain is dry, glue
 the Santa to it.

8 1/2"

2 1/4"

5/8"